Fantasy Art Coloring Book

by
Alison King

Alison is an artist and musician who has lived in Anchorage, Alaska since 1983. She began drawing when she was 3 years old, began playing piano at 4 and attributes her creative talents to multiple generations of musicians and artists in her family history. "It seems to be in my genes, and I honor those previous generations by continuing the legacy. I was always encouraged to follow my heart in these matters". Alison recognized early in life that art and music could be difficult ways to make a living, so she also implemented her practical genes and got a college education. This was primarily so she could have an income that would allow her to draw, paint and play music without being the proverbial starving artist. Alison balances a satisfying career with equally satisfying avocations as a professional musician and part-time artist. Her pen and ink sketches, paintings and beaded jewelry designs have won local fans for many years. Some of Alison's art pieces also reside as far away as California, Wisconsin and Ecuador.

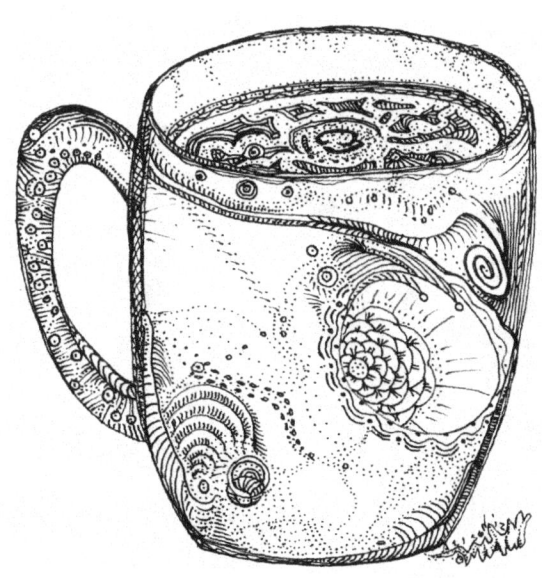

All rights reserved. In accordance with the U.S. Copyright Act of 1976, the scanning, uploading, and electronic sharing of any part of this book without permission of the publisher is unlawful piracy and theft of the author's intellectual property. Thank you for your support of author's rights.

Printed in The United States of America
by Lulu.com

© 2015 Alison King. All rights reserved.
ISBN 9781329639386

Fantasy Art Coloring Book

Contents:

1. Floral Fantasy
2. Baby Elephant
3. Make A Joyful Noise
4. Coy Koi (Shy fish - can you find it?)
5. Seahorse and Cat
6. Faith
7. Hope
8. Love
9. Peace
10. Color The Season
11. Bald Eagle
12. Raven
13. Moose
14. Ram
15. Happy Bear
16. Sunrise with Whale
17. Mandala #1
18. Mandala #2
19. Mandala #3
20. Mostly Birds (Hidden are 10 birds, 2 cats and a shoe - can you find them?)
21. Surf's Up

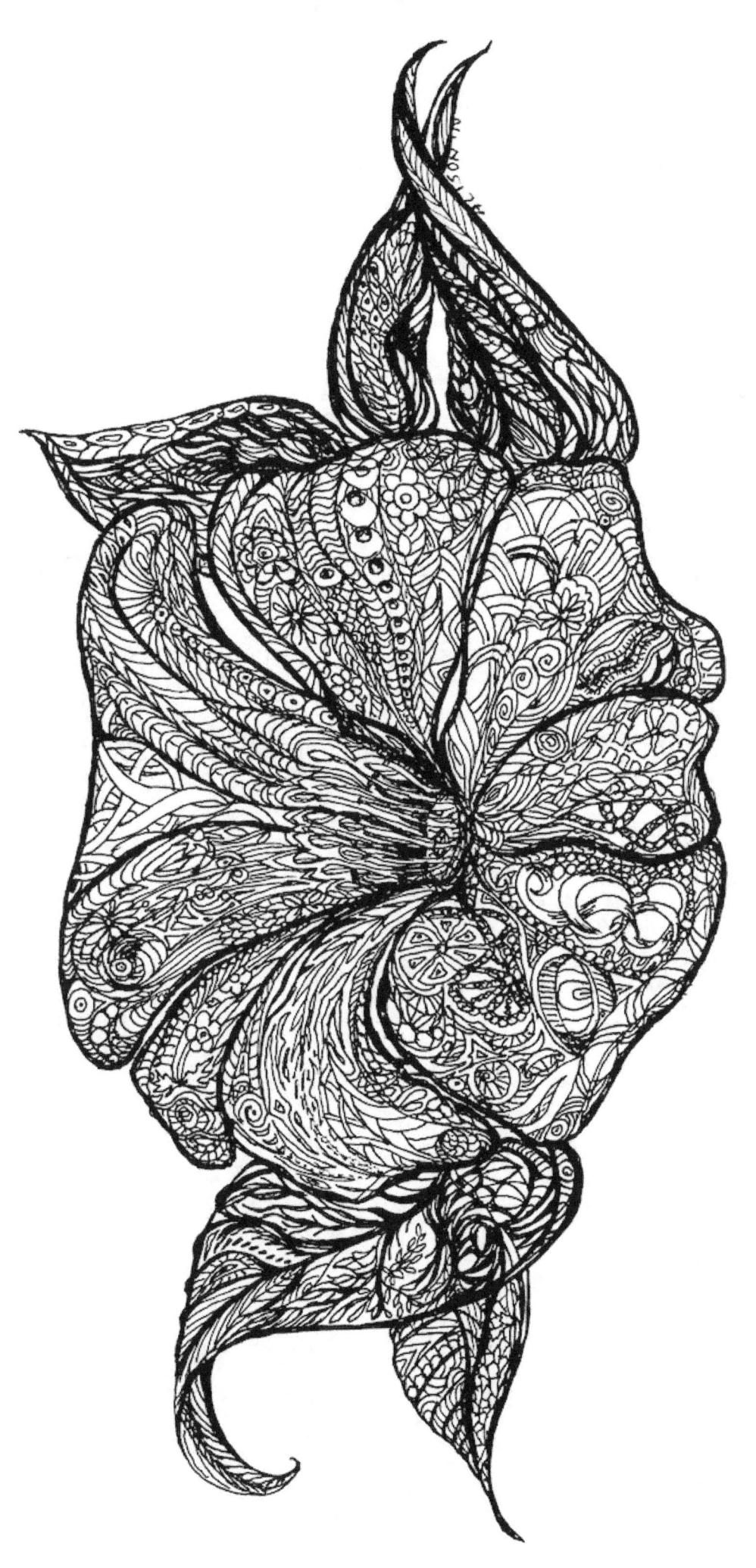

THIS PAGE HAS BEEN LEFT BLANK ON PURPOSE,

SO THE PIECE ON THE OTHER SIDE

IS SUITABLE FOR FRAMING IF YOU CHOOSE

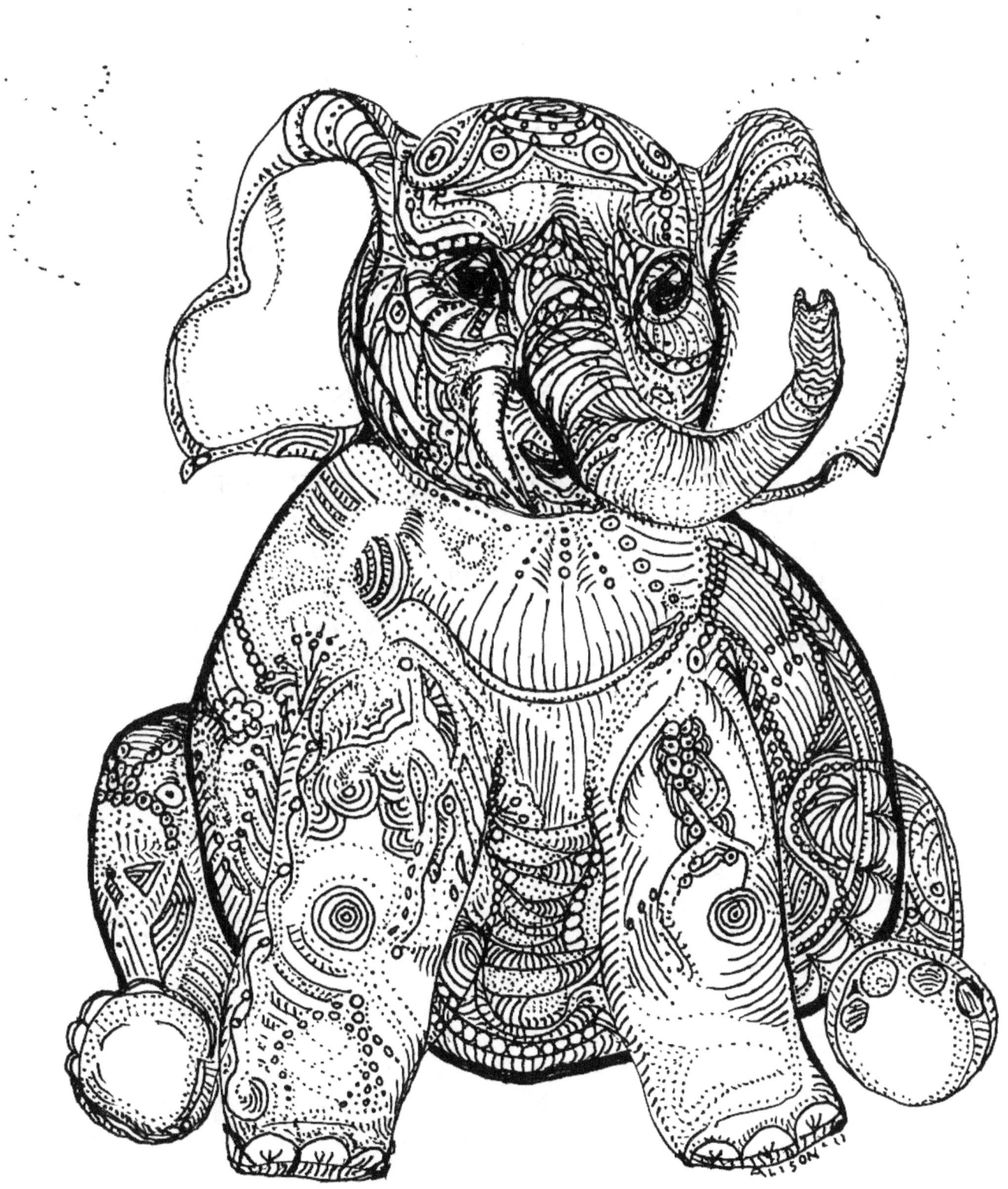

THIS PAGE HAS BEEN LEFT BLANK ON PURPOSE,

SO THE PIECE ON THE OTHER SIDE

IS SUITABLE FOR FRAMING IF YOU CHOOSE

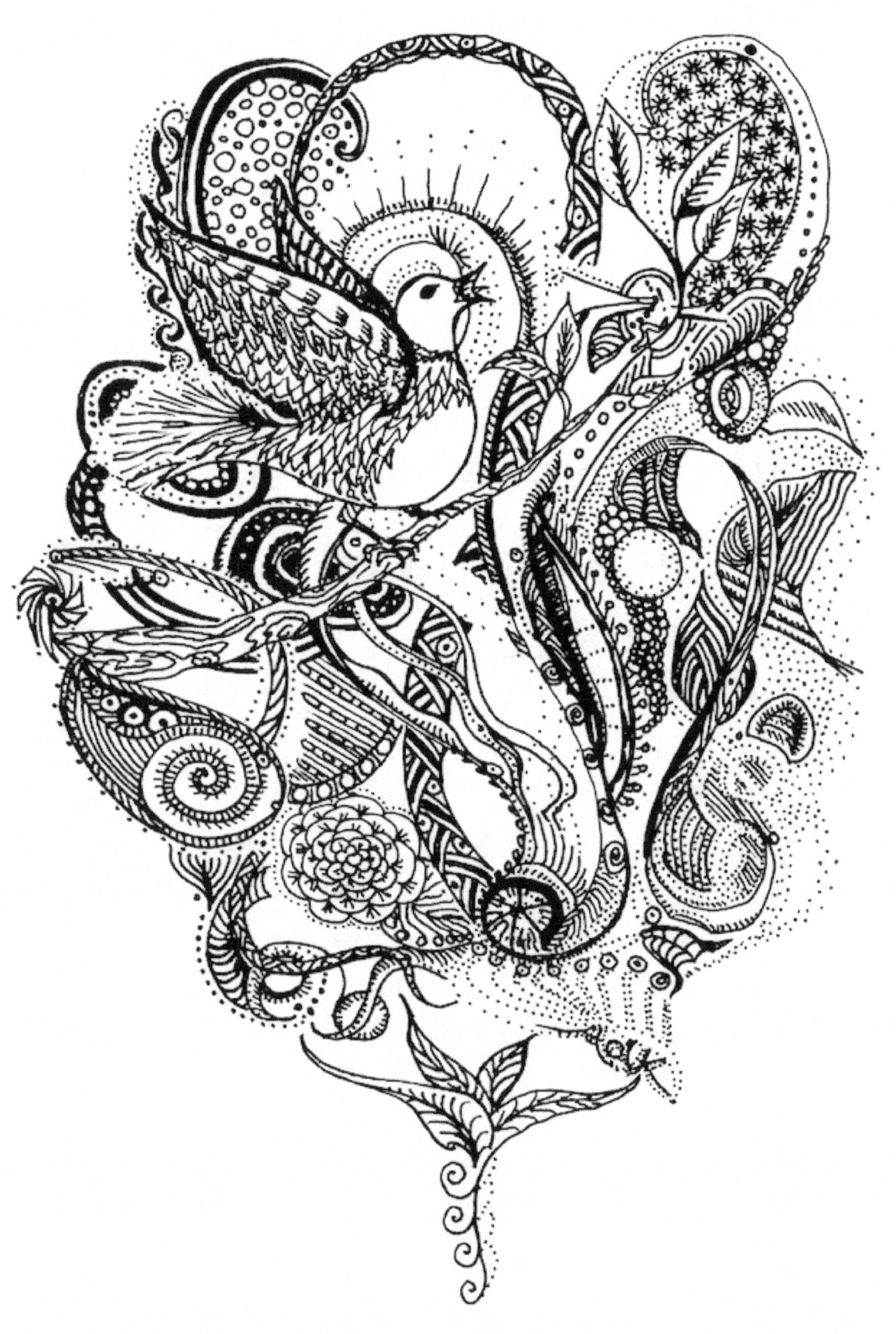

THIS PAGE HAS BEEN LEFT BLANK ON PURPOSE,

SO THE PIECE ON THE OTHER SIDE

IS SUITABLE FOR FRAMING IF YOU CHOOSE

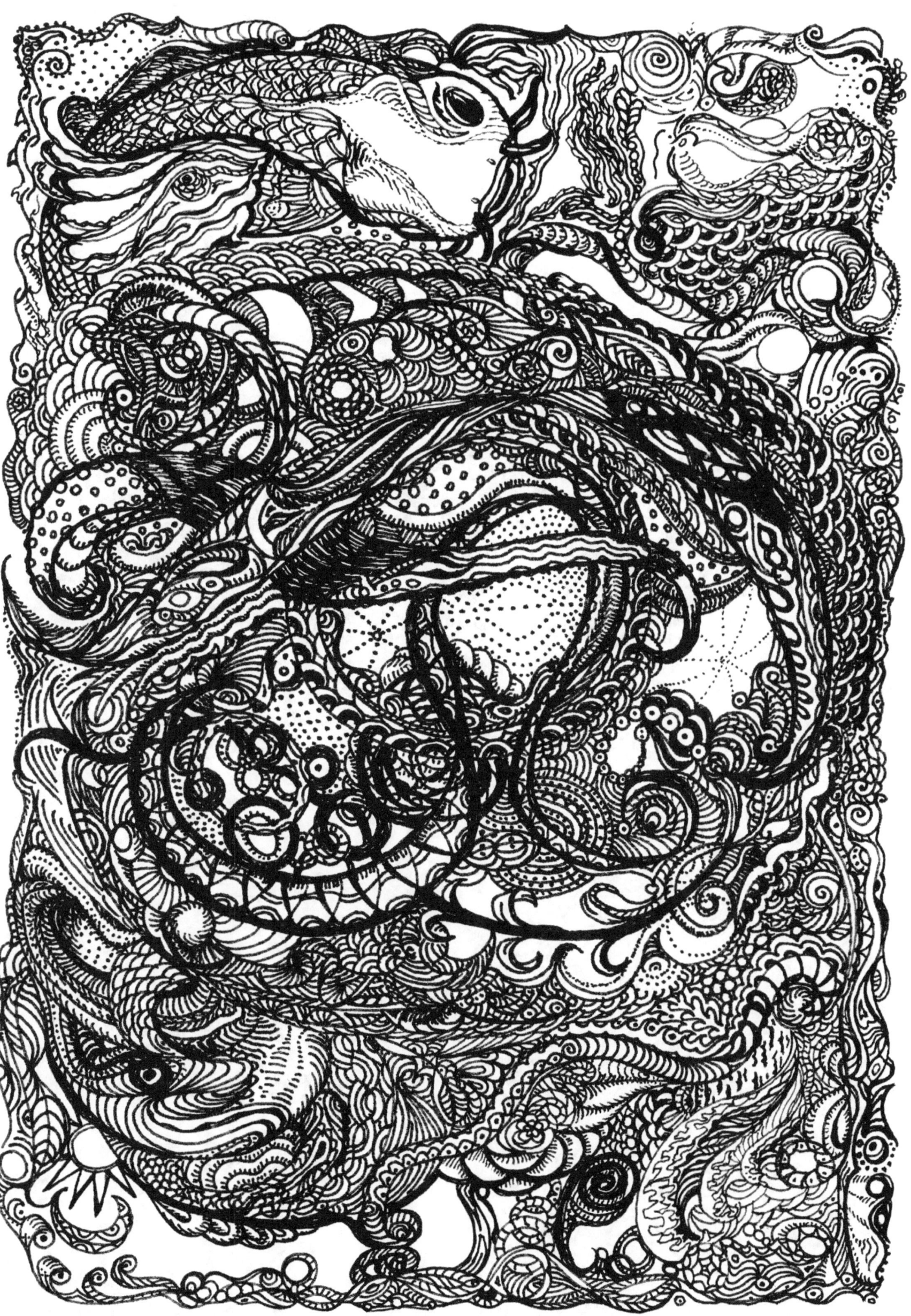

THIS PAGE HAS BEEN LEFT BLANK ON PURPOSE,

SO THE PIECE ON THE OTHER SIDE

IS SUITABLE FOR FRAMING IF YOU CHOOSE

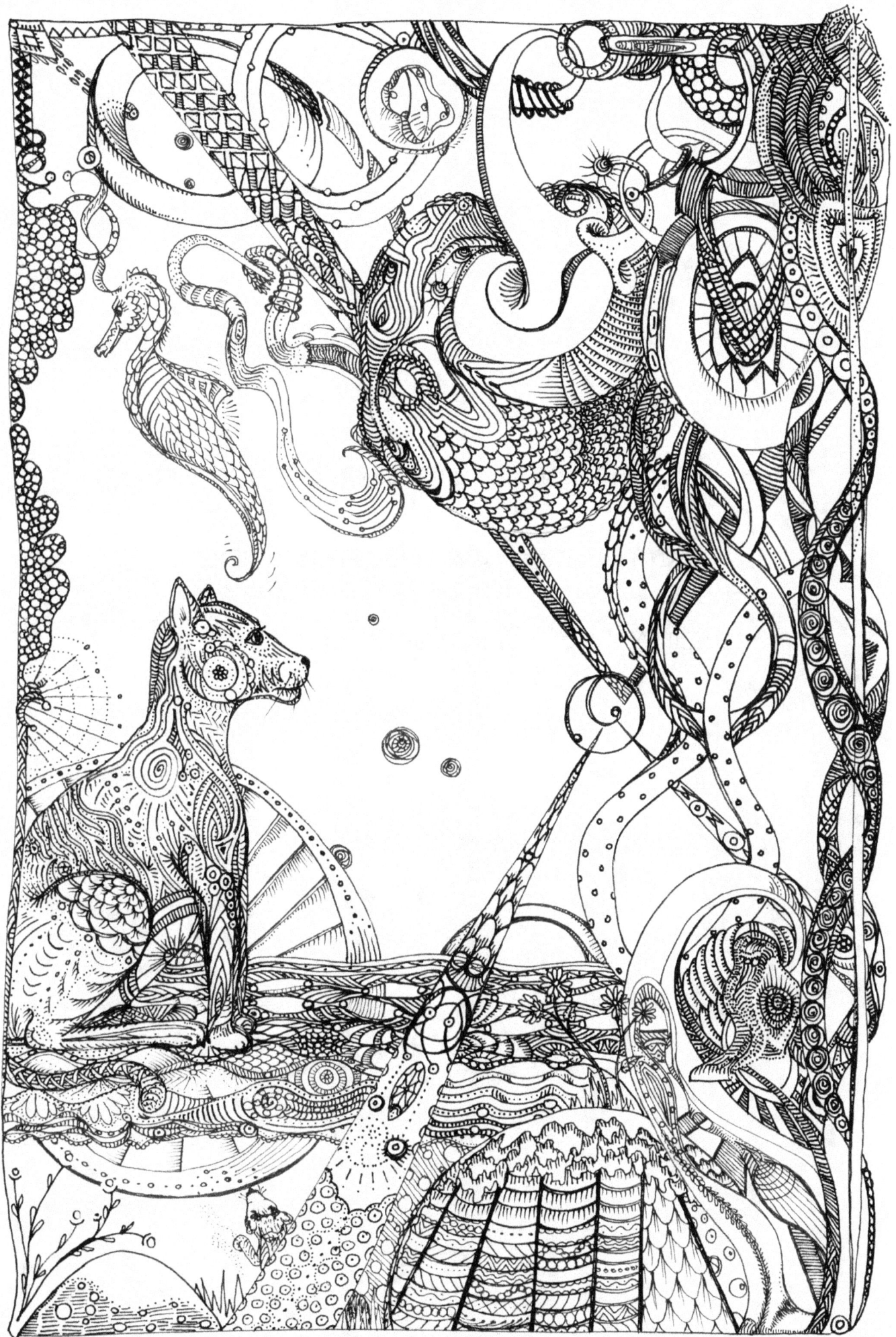

THIS PAGE HAS BEEN LEFT BLANK ON PURPOSE,

SO THE PIECE ON THE OTHER SIDE

IS SUITABLE FOR FRAMING IF YOU CHOOSE

THIS PAGE HAS BEEN LEFT BLANK ON PURPOSE,

SO THE PIECE ON THE OTHER SIDE

IS SUITABLE FOR FRAMING IF YOU CHOOSE

THIS PAGE HAS BEEN LEFT BLANK ON PURPOSE,

SO THE PIECE ON THE OTHER SIDE

IS SUITABLE FOR FRAMING IF YOU CHOOSE

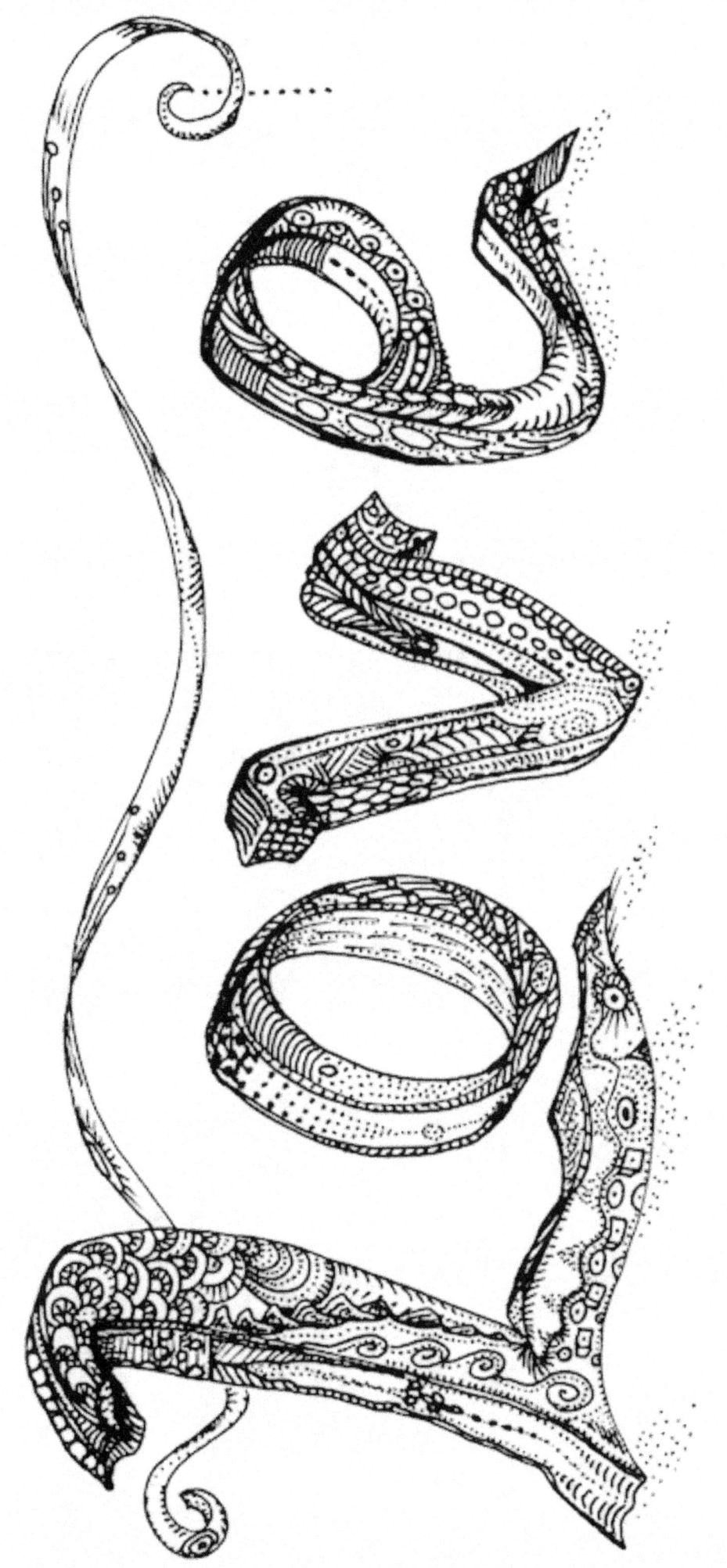

THIS PAGE HAS BEEN LEFT BLANK ON PURPOSE,

SO THE PIECE ON THE OTHER SIDE

IS SUITABLE FOR FRAMING IF YOU CHOOSE

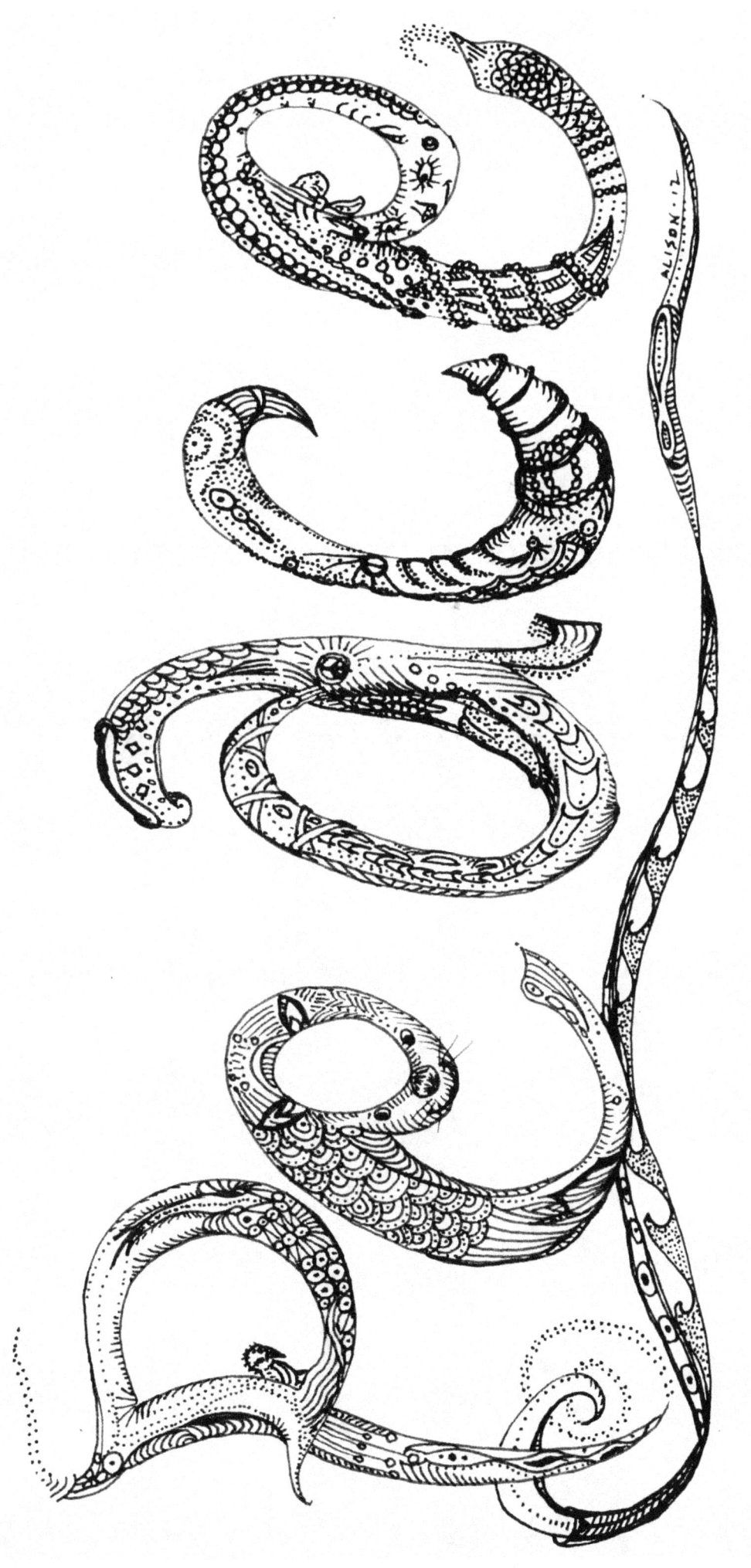

THIS PAGE HAS BEEN LEFT BLANK ON PURPOSE,

SO THE PIECE ON THE OTHER SIDE

IS SUITABLE FOR FRAMING IF YOU CHOOSE

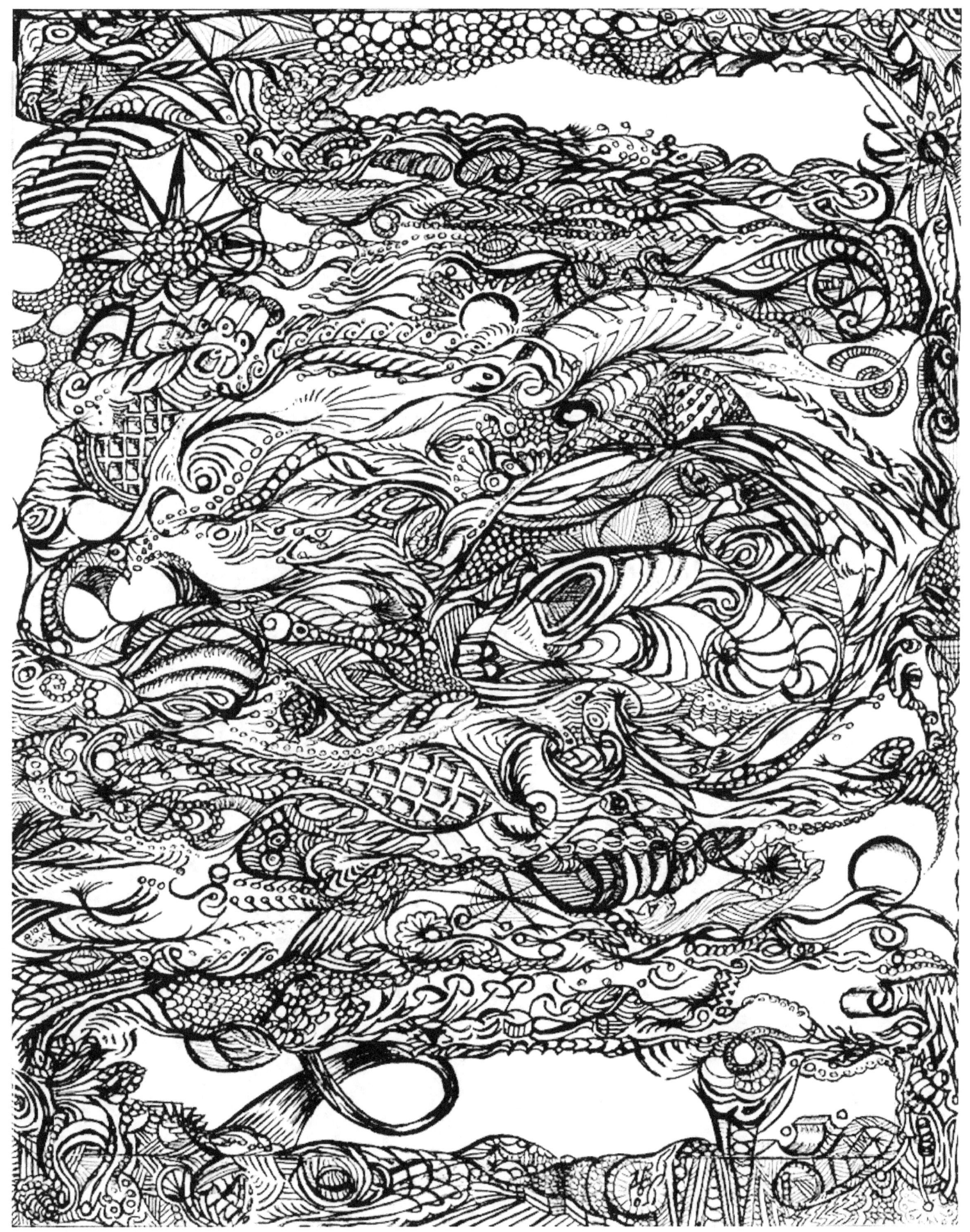

THIS PAGE HAS BEEN LEFT BLANK ON PURPOSE,

SO THE PIECE ON THE OTHER SIDE

IS SUITABLE FOR FRAMING IF YOU CHOOSE

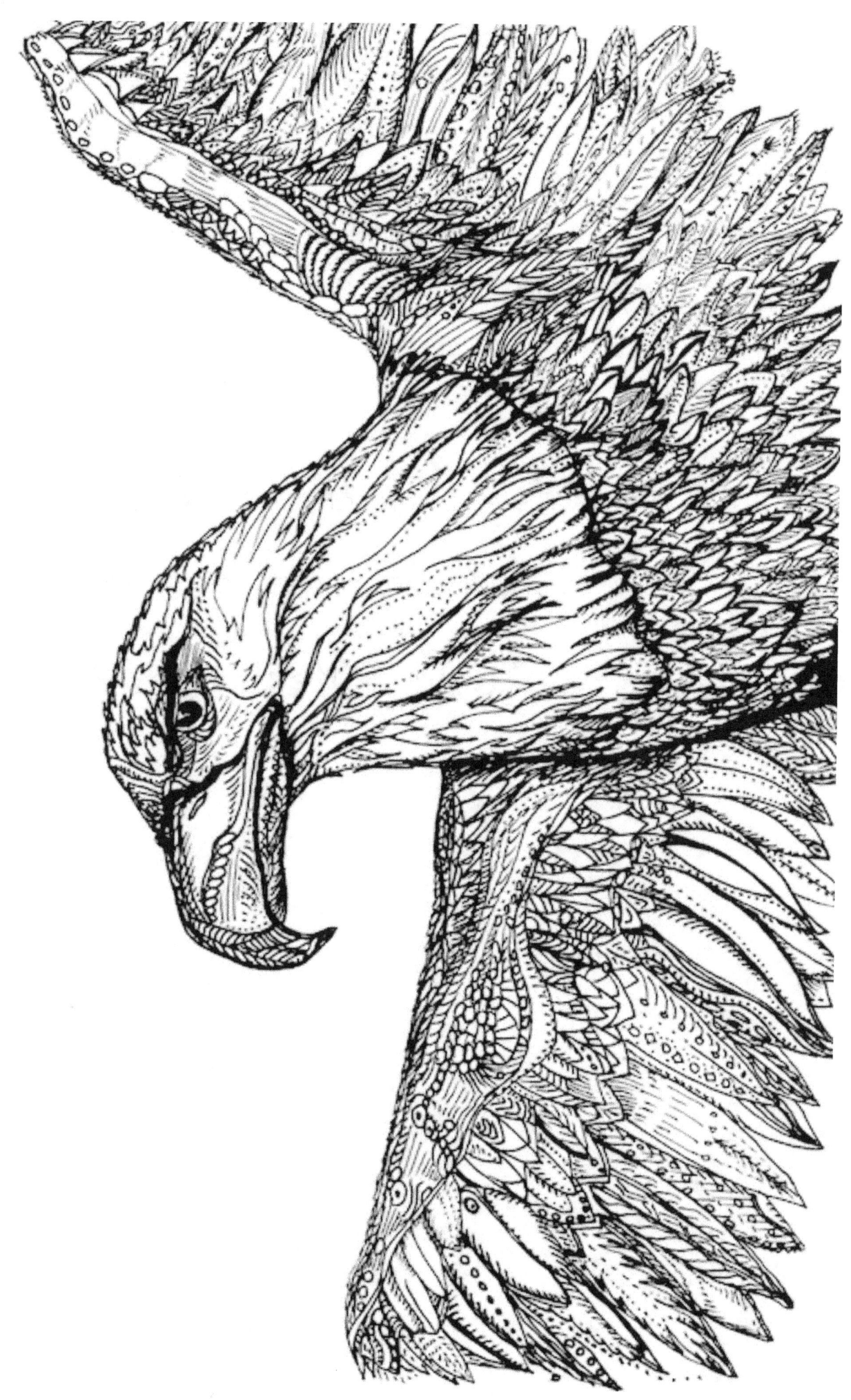

THIS PAGE HAS BEEN LEFT BLANK ON PURPOSE,

SO THE PIECE ON THE OTHER SIDE

IS SUITABLE FOR FRAMING IF YOU CHOOSE

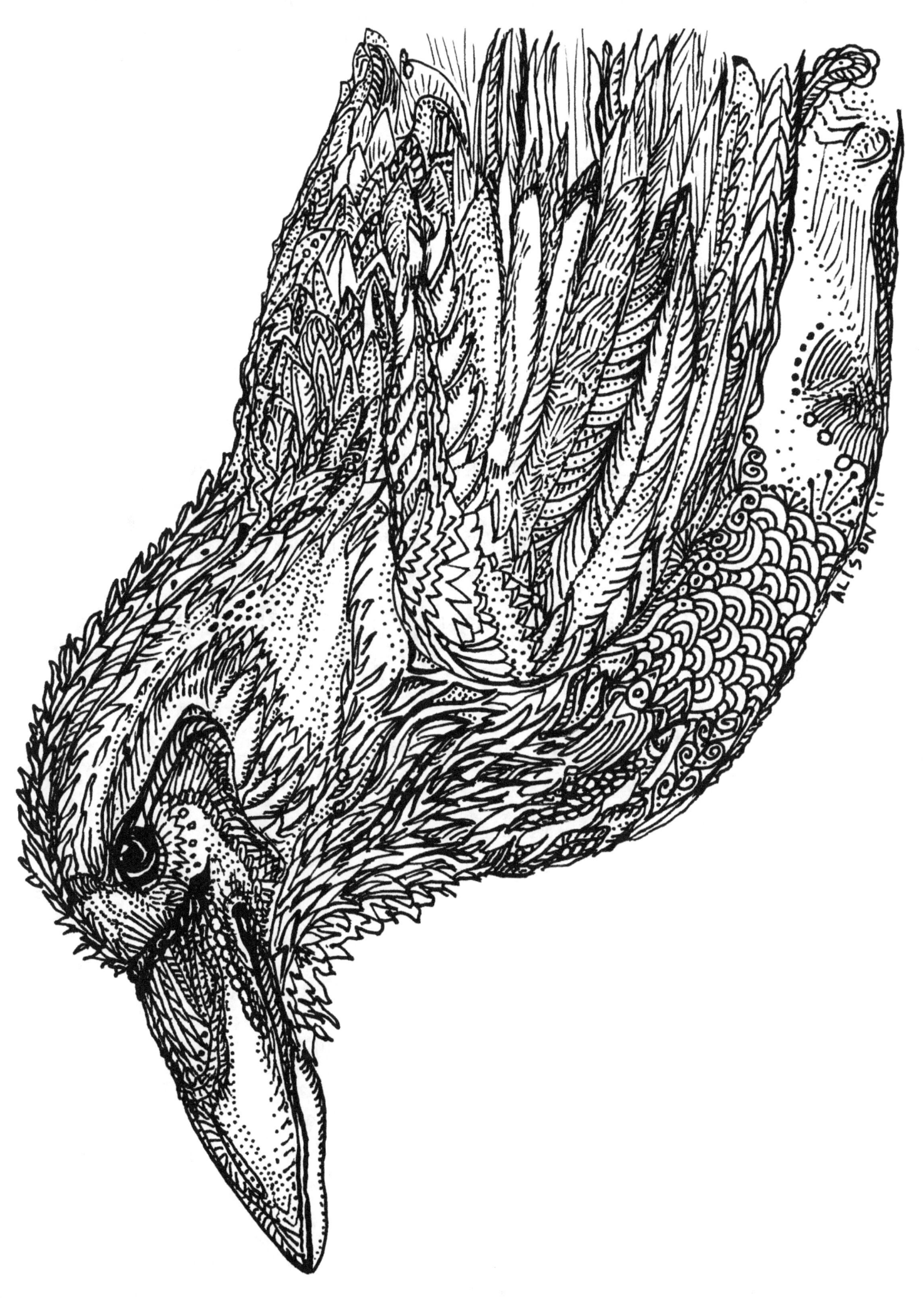

THIS PAGE HAS BEEN LEFT BLANK ON PURPOSE,

SO THE PIECE ON THE OTHER SIDE

IS SUITABLE FOR FRAMING IF YOU CHOOSE

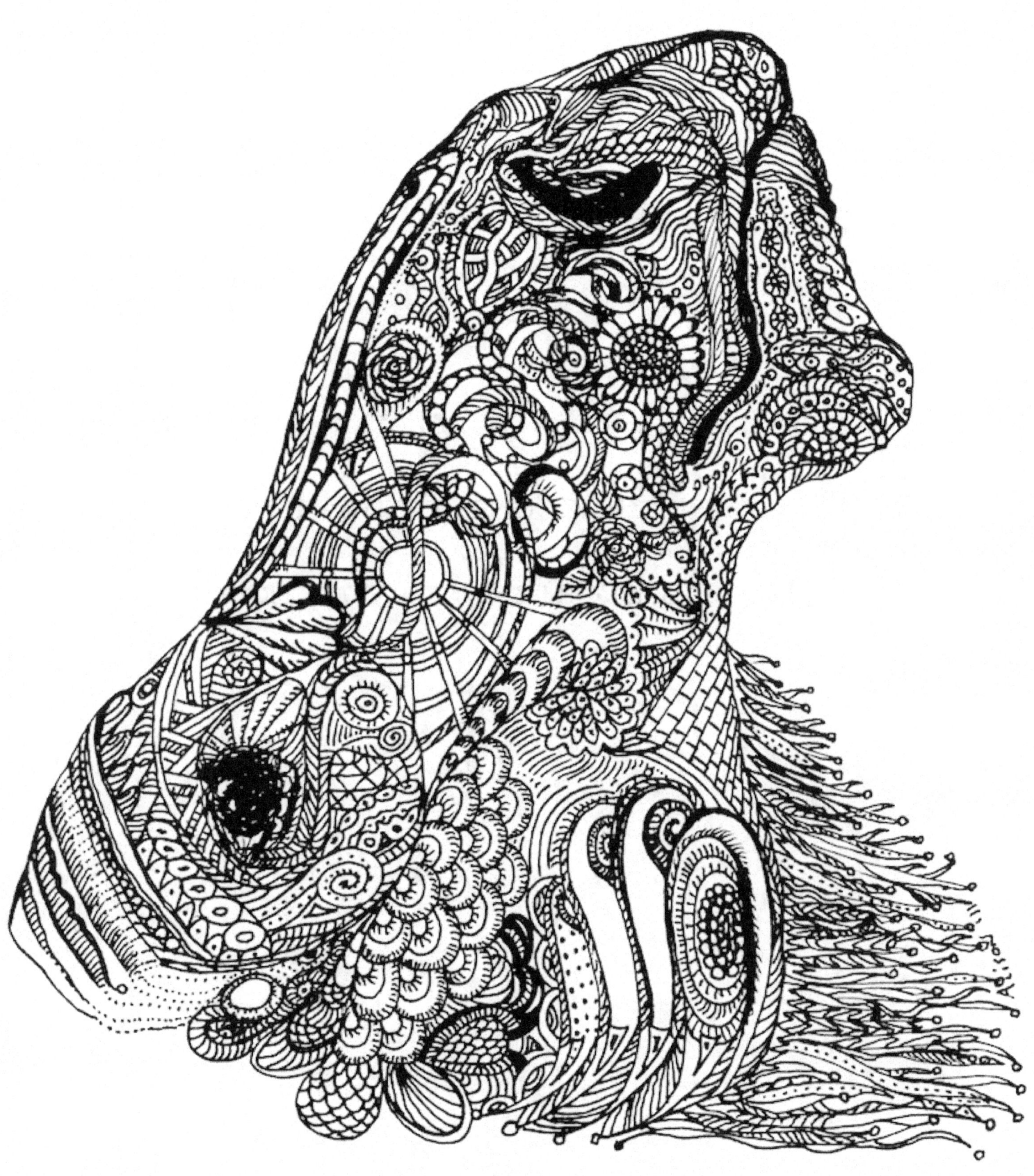

THIS PAGE HAS BEEN LEFT BLANK ON PURPOSE,

SO THE PIECE ON THE OTHER SIDE

IS SUITABLE FOR FRAMING IF YOU CHOOSE

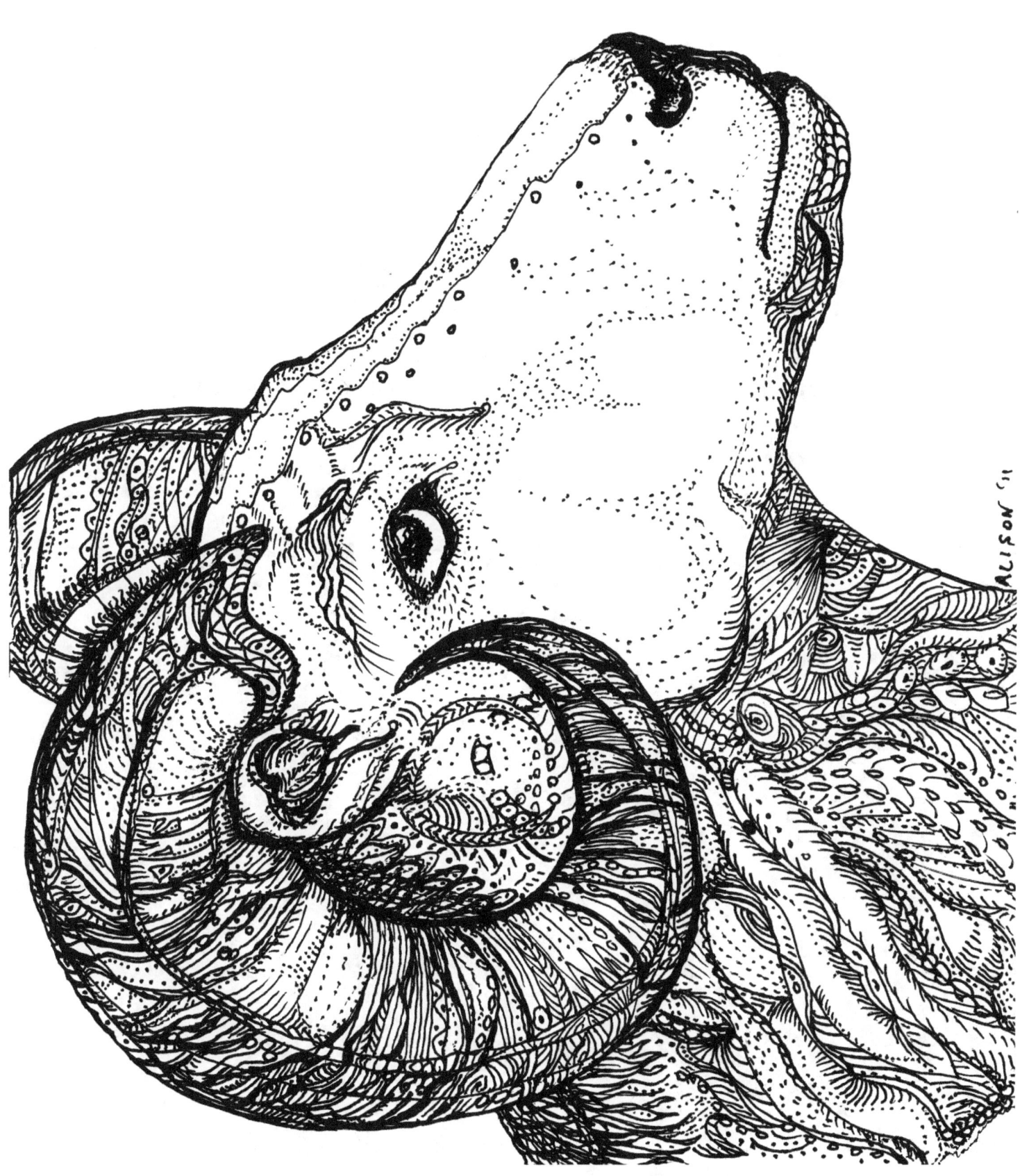

THIS PAGE HAS BEEN LEFT BLANK ON PURPOSE,

SO THE PIECE ON THE OTHER SIDE

IS SUITABLE FOR FRAMING IF YOU CHOOSE

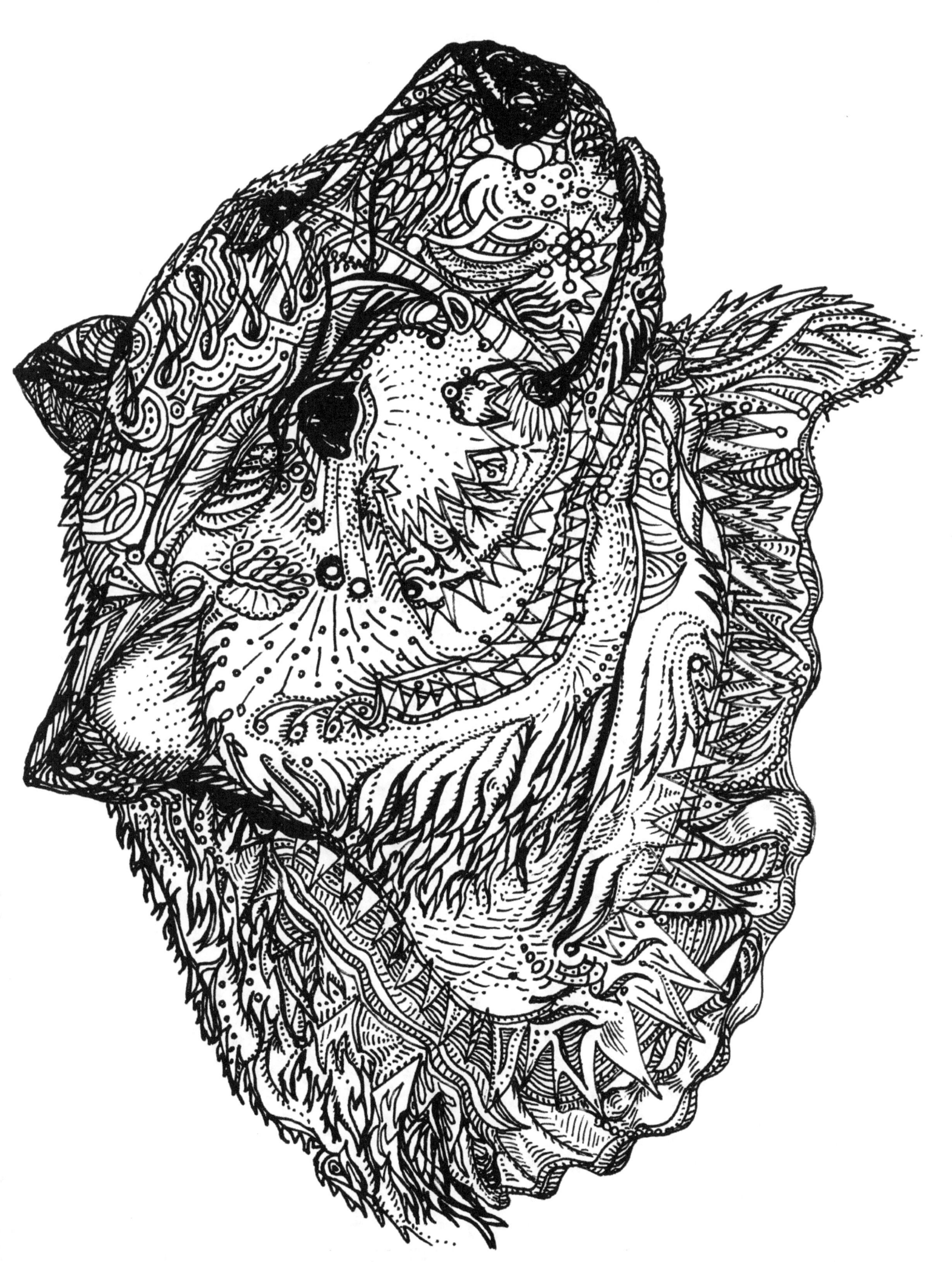

THIS PAGE HAS BEEN LEFT BLANK ON PURPOSE,

SO THE PIECE ON THE OTHER SIDE

IS SUITABLE FOR FRAMING IF YOU CHOOSE

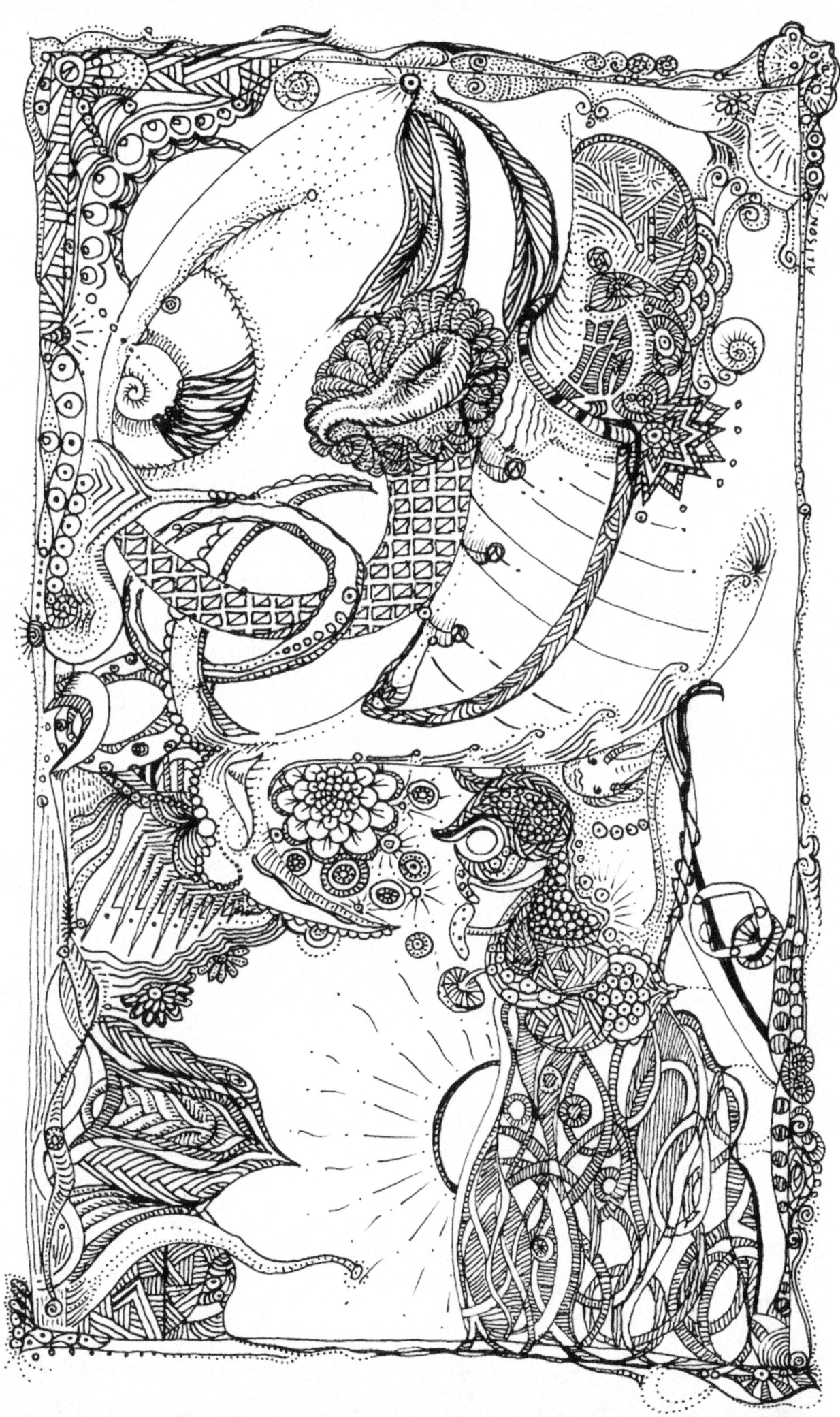

THIS PAGE HAS BEEN LEFT BLANK ON PURPOSE,

SO THE PIECE ON THE OTHER SIDE

IS SUITABLE FOR FRAMING IF YOU CHOOSE

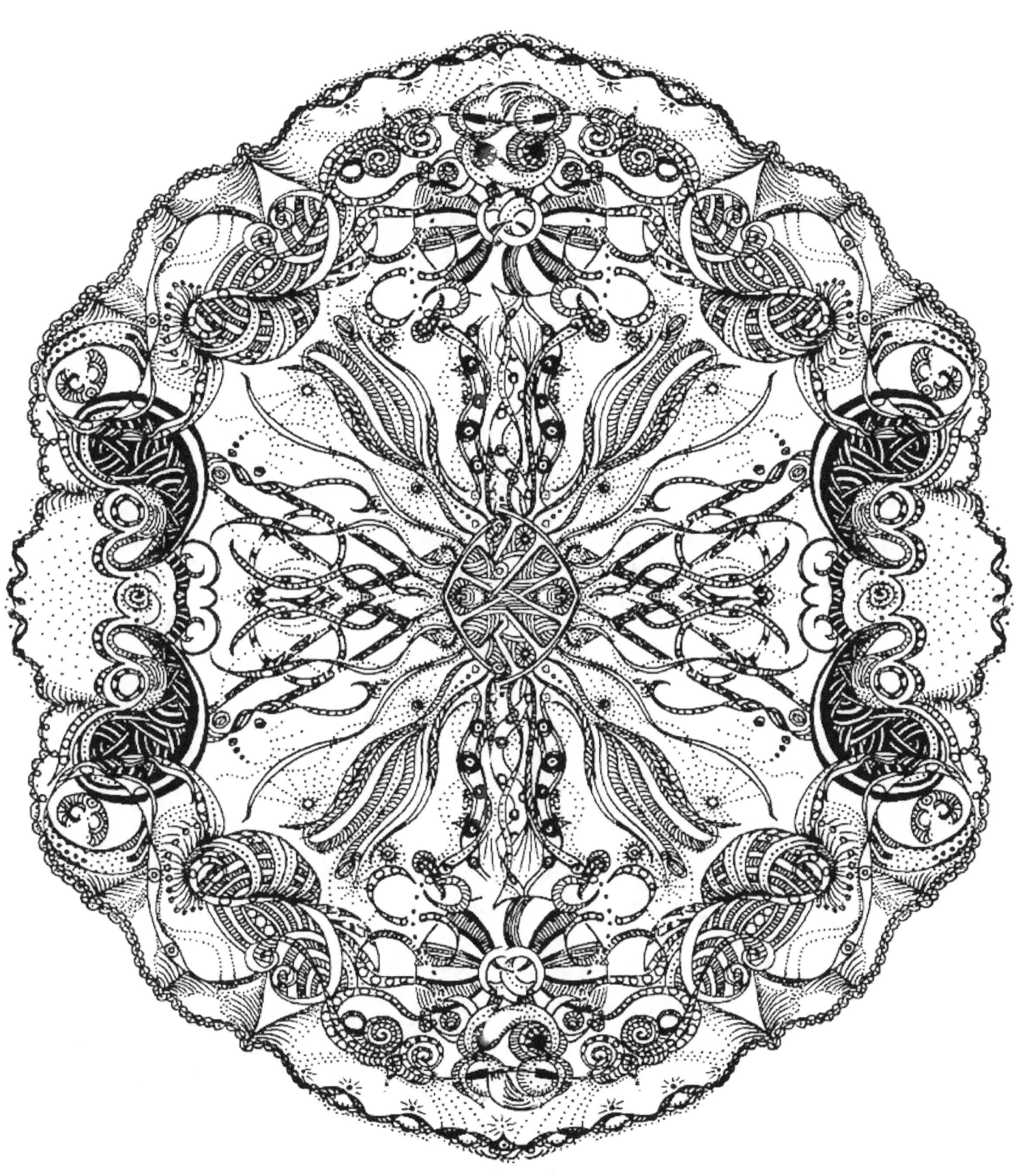

THIS PAGE HAS BEEN LEFT BLANK ON PURPOSE,

SO THE PIECE ON THE OTHER SIDE

IS SUITABLE FOR FRAMING IF YOU CHOOSE

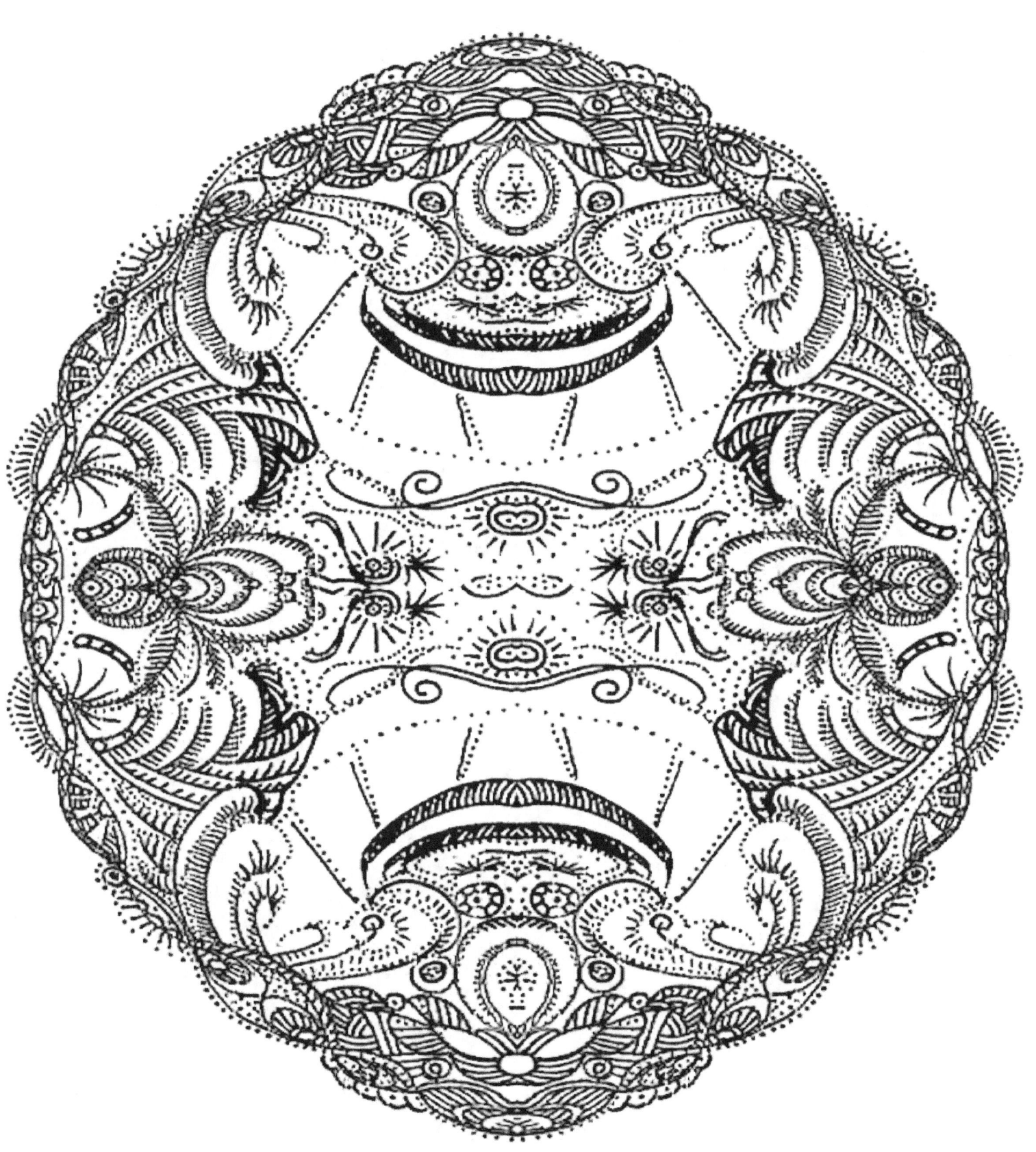

THIS PAGE HAS BEEN LEFT BLANK ON PURPOSE,

SO THE PIECE ON THE OTHER SIDE

IS SUITABLE FOR FRAMING IF YOU CHOOSE

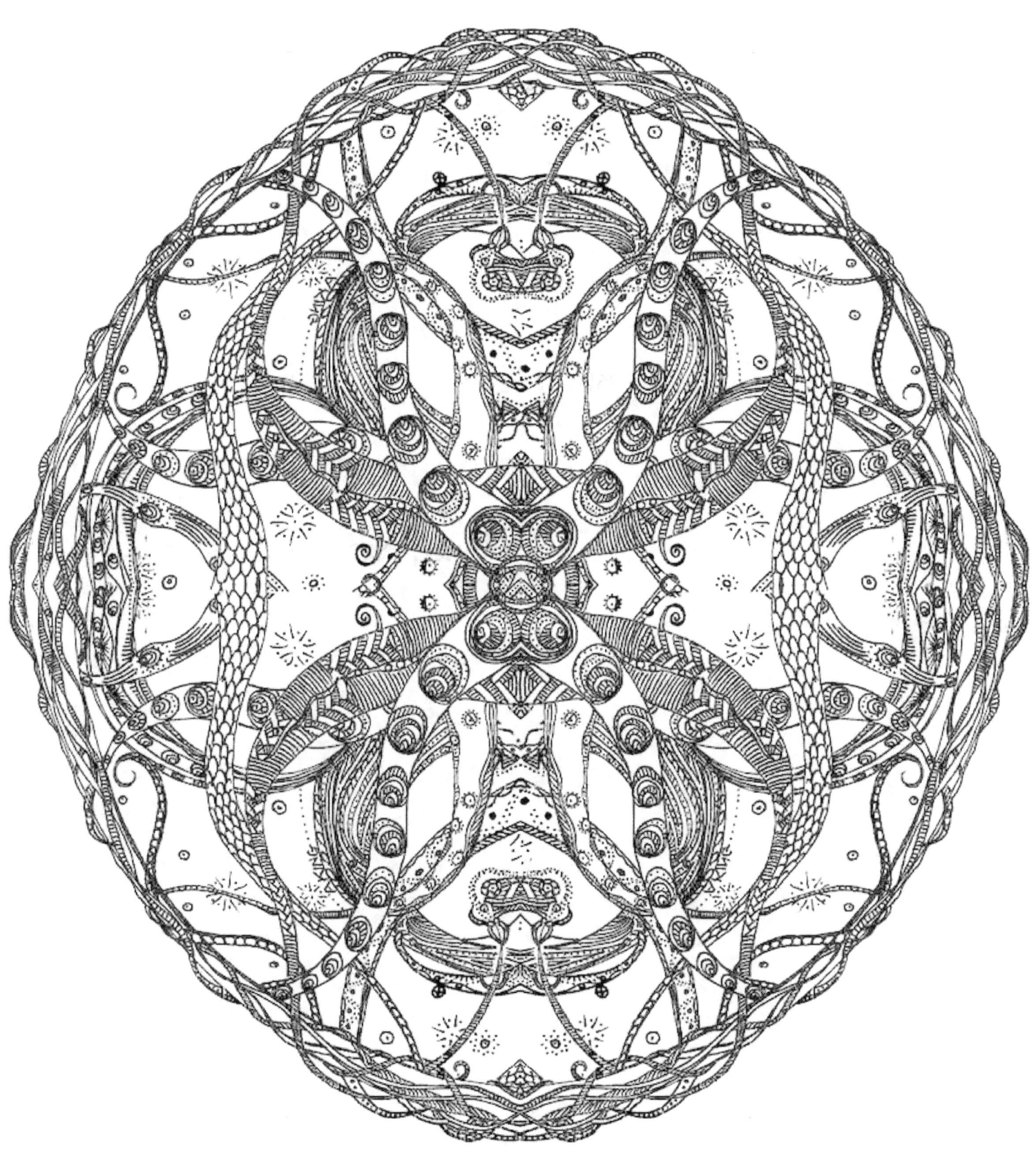

THIS PAGE HAS BEEN LEFT BLANK ON PURPOSE,

SO THE PIECE ON THE OTHER SIDE

IS SUITABLE FOR FRAMING IF YOU CHOOSE

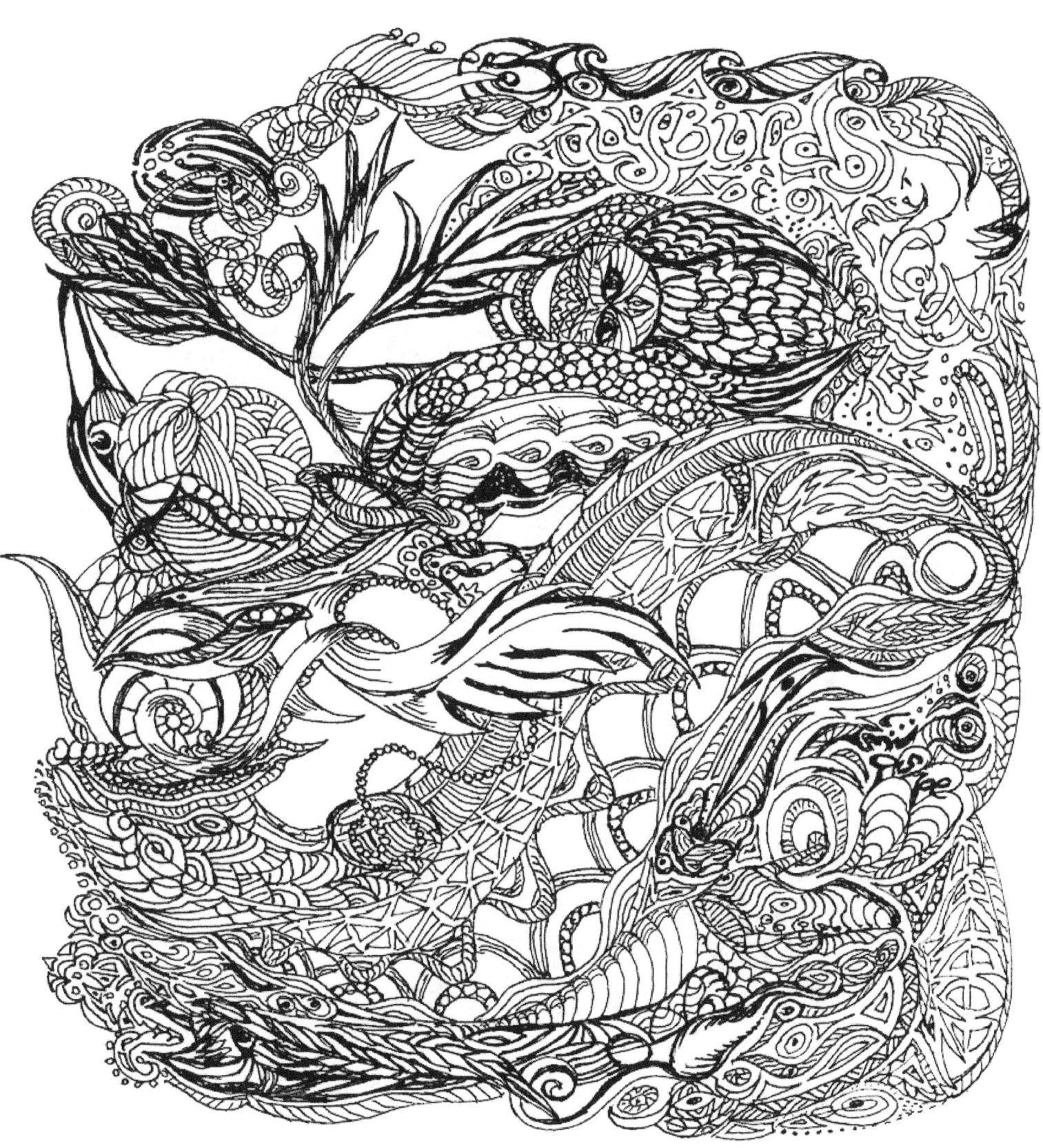

THIS PAGE HAS BEEN LEFT BLANK ON PURPOSE,

SO THE PIECE ON THE OTHER SIDE

IS SUITABLE FOR FRAMING IF YOU CHOOSE

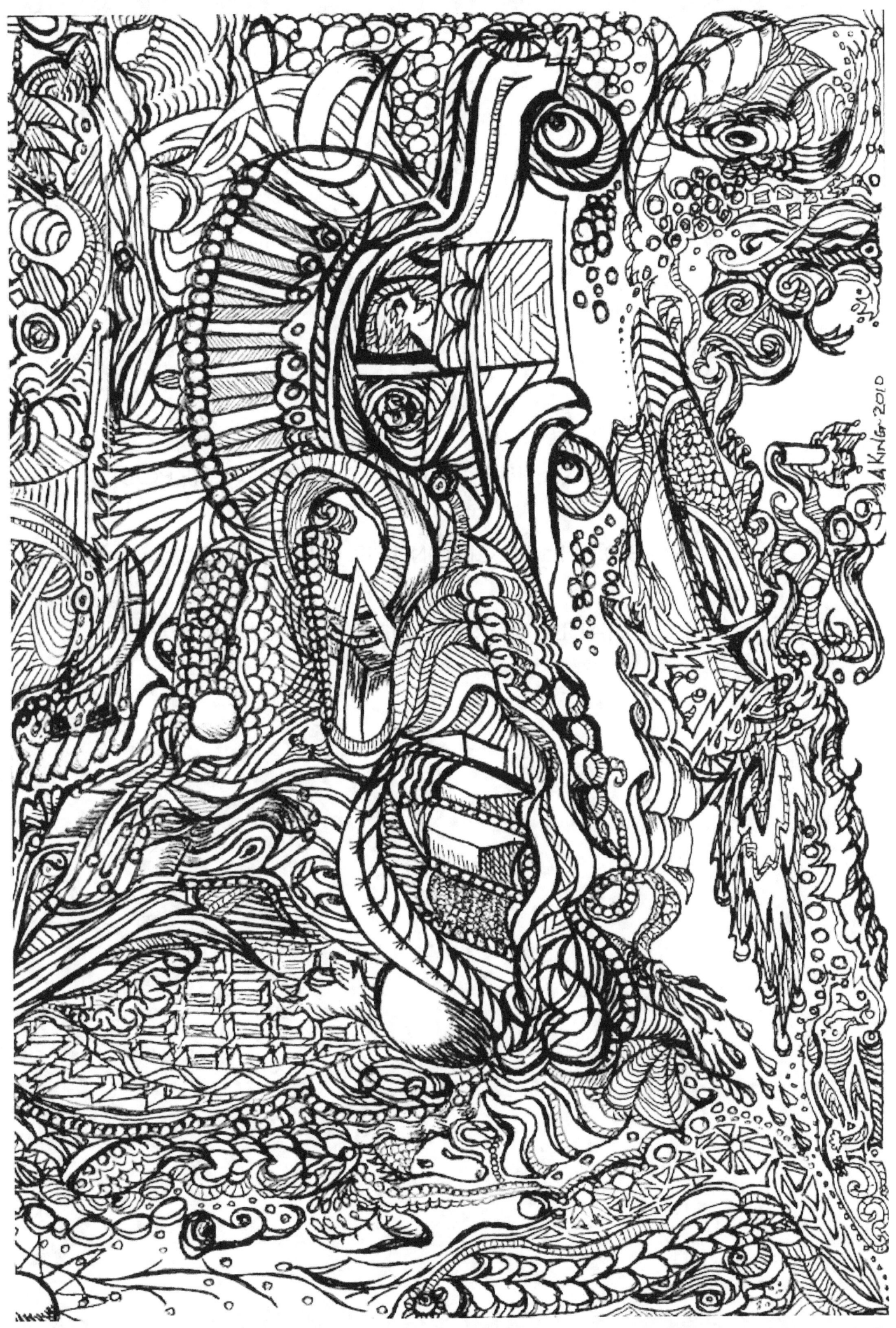

THIS PAGE HAS BEEN LEFT BLANK ON PURPOSE,

SO THE PIECE ON THE OTHER SIDE

IS SUITABLE FOR FRAMING IF YOU CHOOSE

www.ingramcontent.com/pod-product-compliance
Lightning Source LLC
Chambersburg PA
CBHW080849170526
45158CB00009B/2687